HEY HUMAN,
SEE WHAT YOU DO!?

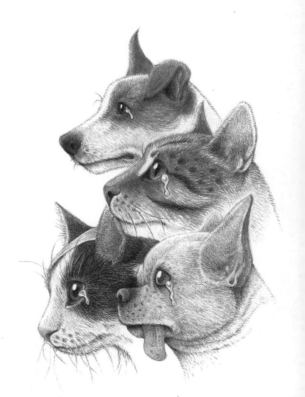

A catalogue record for this book is available from the British Library.

First published in Great Britain in 2024
by Carpet Bombing Culture.
An imprint of Pro-actif Communications.
Email: books@carpetbombingculture.co.uk

Hey Human, See What You Do!? by Milk DoNg

Essay by Patrick Potter
Info compiled by: Gary Shove

ISBN: 978-1-908211-97-2

THIS BOOK FIGHTS FOR ANIMAL RIGHTS

100% of the profits realised by the publisher will be donated to animal welfare charities.

www.carpetbombingculture.com

Milk DoNg

Hey Human,
See What You Do!?

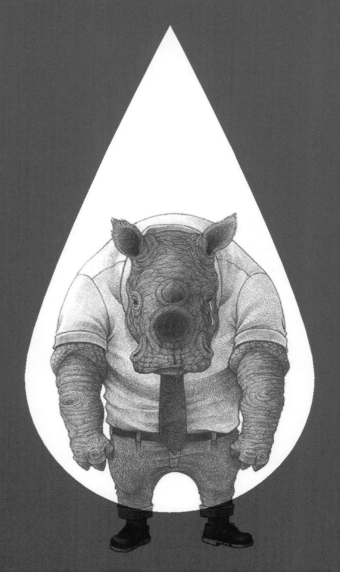

HEY HUMAN
. . . GOODBYE.

Imagine a world so fecund, so teeming with life that the seas broiled with turtles and the land thronged with mega herds of animals. And then we arrived...

WE ARE VERY HUNGRY MONKEYS. AND WE LIKE AN EASY LUNCH.

Around 1600 Europeans arrived on what we now call Mauritius. They came across a large flightless bird waddling about the place looking like a 23kg plate of delicious meat. It took about 80 years to kill them all.

Even when it must have become obvious that the birds were dying out, it was still easier to go and kill one and have a feast than to think about some coordinated way to maintain the population. We take the path of least resistance.

THE DODO BECAME THE SYMBOL OF HUMAN CAUSED EXTINCTION.

Fast forward four hundred years and we are now experiencing what many scientists call the sixth mass extinction. This is the anthropocene extinction, so called because we're pretty damn sure that the whole thing is a direct result of our activities.

These are the four horsemen of the human centred apocalypse:

- Overhunting and overfishing.

- Habitat destruction, mostly through farming. (including pollution and climate change.)

- Introduction of foreign predators, and diseases.

- Eliminating the competition. (Who's afraid of the bad wolf?)

HEY HUMAN, SEE WHAT YOU DO!?

It's difficult to agree on numbers but we are causing a biodiversity crisis that is terrifying to think about. A 2018 study from PNAS calculated an 83% reduction in the total biomass of wild animals since the dawn of human civilization. And the dawn of civilization is really the dawn of agriculture. Farming is our superpower. It is the cause of our population boom. It puts us at the top of every food chain in the world.

IT'S NO LONGER ENOUGH TO CALL US THE APEX PREDATOR, THERE IS A NEW TERM NOW: GLOBAL SUPERPREDATOR.

WE ARE THE KILLERS OF THE KILLERS.

The illustrations here are all of well known, charismatic animals. These are the animals that fill our children's books and family movies. They have deep cultural importance. And their populations are terrifyingly small. There's hardly any of them left. Mountain gorillas number fewer than 1000. We're losing them. And if we can't save the celebrities, what hope is there for the unknown species?

This is not just a book about extinction. It's also a book about the routine cruelties that we inflict on animals, both domestic and 'wild'. And there is a connection between our capacity for animal cruelty and the tendency towards wiping other species out. Our ability to compartmentalise 'animals that are no more than animate objects' and 'animals that we can empathise with' is what makes us able to watch Peppa pig while eating a bacon sandwich.

This is where Milk DoNg's uncomfortable comics come in. With razor sharp satire his work pierces through the mental gymnastics we do to justify our exploitation and gets to the bit where it just doesn't feel right. It's a childlike insistence on the bare facts. It's just plain cruel.

HEY HUMAN, SEE WHAT YOU DO!?

These humanised animals are crying, they're suffering awful physical pain, and they're talking to us. Their gaze makes us feel our responsibility towards them. If we have to think of animals as being human in order to feel any responsibility towards them, then this is what the artist serves up. Cruelty to animals is a hard problem, so we put it at the bottom of our to-do lists and it consequently is never addressed.

Milk DoNg is doing something as old fashioned as political art, he's using drawing to make a protest. And the drawings are compelling enough to make us want to look at them, in spite of how disturbing they are. It's a clever trick. The appeal of the macabre, put to good use as propaganda for a good cause. They sit in the back of the mind, nagging you to think about your relationship with animals.

Nobody wakes up in the morning and sets out to wipe out animal life. Nobody wants to do the business of mass extinction, and yet our collective everyday actions and inactions add up to the anthropocene mass extinction event.

MOST EXTINCTIONS ARE OF SPECIES THAT HAVE NOT EVEN BEEN DISCOVERED.

They blink out of existence before we ever lay eyes on them, and we will never know they existed. The pictures you will not see in this book, the strangers we destroyed without even knowing who they were. Not just most, but the vast majority of extinctions are thought to be like this. You can imagine these ghosts haunting this book, pages between pages.

Drawing the dots between our trivial daily activities and the gravely important global picture of mass extinction seems to be impossibly hard. In the grind for survival and the information overload of modern life, who has the time or the presence of mind to do anything?

How do you even decide what to do?

HEY HUMAN, SEE WHAT YOU DO!?

There is no doubt that reconsidering how we feed ourselves is going to be a massive part of any potential solution. But personal choices will not be enough. International cooperation on a never before seen level will be required.

And an awareness of social justice is also important, poachers poach because they're excluded from any other form of economic success. Westerners should not lecture people in developing countries on moral standards about animal cruelty, without recognising economic inequalities.

In the end it is beyond the scope of this project to offer a solution. But art is excellent for starting the conversation. Rendering these animals as characters is a powerful way of triggering our empathy. It highlights the hypocrisy of putting these animals in blockbuster movies and classic literature while still treating them with awful cruelty. It forces us to think about an unpleasant aspect of our nature.

And then maybe, it becomes a starting point for something hopeful.

These animals are the victims of our ingenuity. They could become the beneficiaries of that ingenuity. The sixth extinction demonstrates beyond all possible doubt, that human activity can change the world. The global response to Covid 19 was not perfect but it showed that we can cooperate on an international level when we really want to.

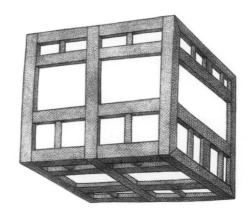

HEY HUMAN,

...This book could be
the start of a conversation,
or a process
of self-education.

It could be
the start of a journey for you,
and then who knows...?

SEE WHAT YOU DO!?

Human Fashion

INVOICE

Invoice No : Uncountable Bill To : Human
Issue Date : Everyday
Due Date : Today

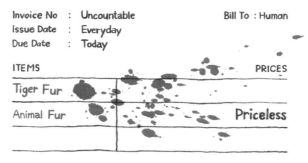

ITEMS	PRICES
Tiger Fur	
Animal Fur	Priceless

WE APPRECIATE YOUR SUPPORT

[1]100 years ago it was estimated that there were 100,000 tigers worldwide, today it is thought that there are probably fewer than 5,000.

[2]Tigers are still under threat today through poaching which feeds the illegal international trade in their skins. While legislation has been introduced these trades still flourish underground.

[3]'Big cat' farms exist where tigers are confined to small cages then eventually slaughtered. Their body parts are used for traditional medicines, their bones soaked in alcohol to create 'tiger wine' and their skins made into rugs. Even their flesh can be found sold in some restaurants.

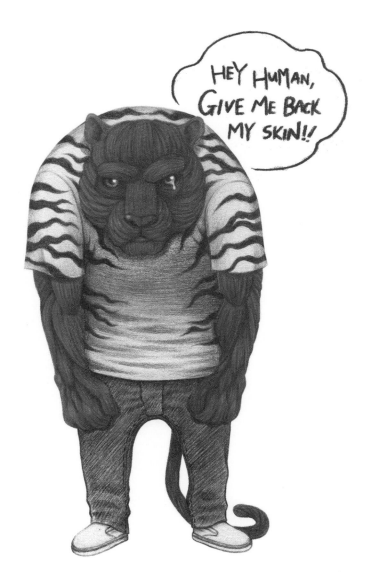

Human Fashion

INVOICE

Invoice No	: Uncountable	Bill To	: Human
Issue Date	: Everyday		
Due Date	: Today		

ITEMS	PRICES
Crocodile Leather	
Animal Leather	**Priceless**

WE APPRECIATE YOUR SUPPORT

[1] In the wild some crocodies and alligators can expect to live to a 100 years old. In the crocodile and alligator skin industry these reptiles are killed as young as two years old.

[2] In the wild some saltwater crocodiles can travel over 10km at a time, in Australia when confined to factory farms they are legally required to recieve only .25 to .5 sq metres of space, kept alone in barren cages.

[3] In Vietnam factory farmed crocodiles are bred for the fashion industry. Packed into concrete pits. Firstly they are electroshocked, then to kill them their necks are cut open and rods rammed down their spines. They are then skinned, a process that can take 15 to 20 minutes per animal.

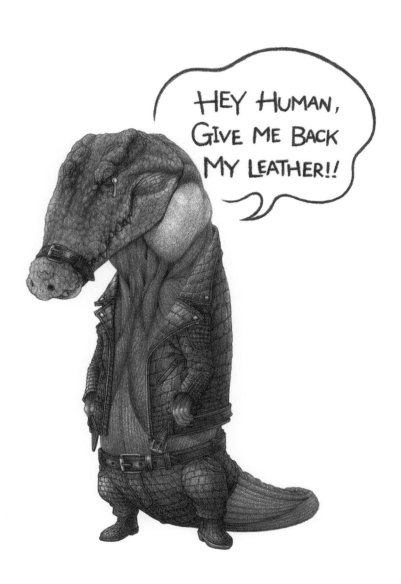

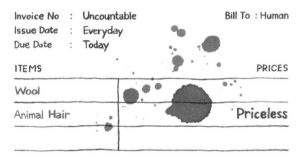

Human Fashion

INVOICE

Invoice No	:	Uncountable		Bill To : Human
Issue Date	:	Everyday		
Due Date	:	Today		

ITEMS	PRICES
Wool	
Animal Hair	Priceless

WE APPRECIATE YOUR SUPPORT

[1]A PETA investigation of more than 30 shearing sheds in the USA and Australia uncovered rampant abuse. Shearers were caught punching, kicking and stomping on sheep in addition to hitting them in the face with electric clippers and standing on their heads, necks and limbs.

[2]To increase profits sheep can be bred to grow excessive amounts of wool to increase profits, weighing down on their bodies and making it difficult to move and stand.

[3]Lambs are subject to tail-docking, ear hole punching and males can be castrated without the use of painkillers within weeks of their birth. Some lambs may also be forced to endure a brutal and unimaginably agonizing procedure called mulesing in which large strips of skin and flesh are cut from their back often without painkillers.

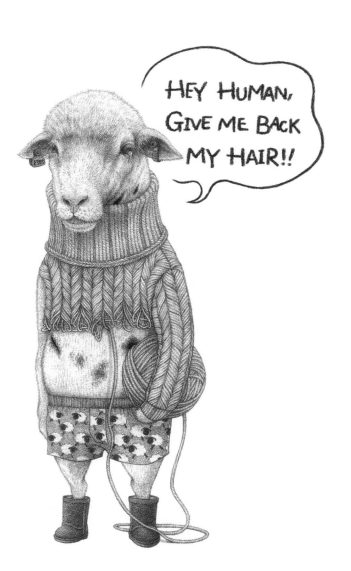

Human
BEAUTY & SKINCARE

invoice
No. Uncountable
DATE: Everyday

ITEM DESCRIPTION	QTY.	PRICE
Skincare Product	∞	Priceless
Cosmetics Product	∞	Priceless
Makeup Product	∞	Priceless
		Priceless

PAYMENT INFO
A/C No: Uncountable
A/C Name: Human

thank you

[1] Over 100 million animals are burned, crippled, poisoned, and abused in US labs every year.

[2] Mice, rats, birds, reptiles and amphibians are exempt from the minimal protects set up under the Animal Welfare Act (AWA).

[3] Up to 90% of animals used in U.S. labs are not counted in the official statistics of animals tested.

[4] According to the Humane Society, registration of a single pesticide requires more than 50 experiments and the use of as many as 12,000 animals.

[5] A Pew Research poll found that 52% of US adults opposed the use of animals in scientific research.

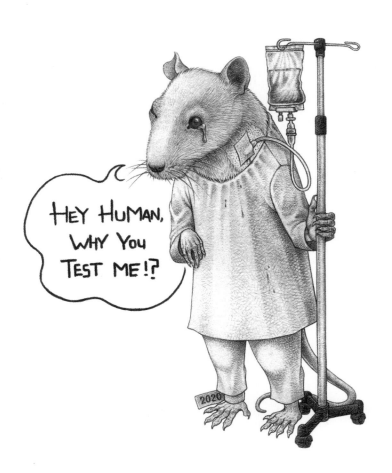

Human
BEAUTY & SKINCARE

invoice
No. Uncountable
DATE Everyday

ITEM DESCRIPTION	QTY.	PRICE
Animal Hair Makeup Brushes	∞	Priceless

Priceless

thank you

PAYMENT INFO
A/C No: Uncountable
A/C Name: Human

[1]Badgers can be bred and confined to small cages on farms before being violently killed for make-up, paint and shaving brushed.

[2]Badgers are extremely social animals and in the wild live in setts that can be centuries old and inhabited by many generations of the same badger clan, having separate rooms for sleeping and a designated 'bathroom' outside the setts. Yet on badger hair farms they are deprived of the opportunity to dig or forage for food or do anything that would make their lives worth living.

[3]Kept in such a horrific environment these conditions often cause badgers to exhibit behaviour patterns indicative of severe psychological distress and suffer untreated physical injuries.

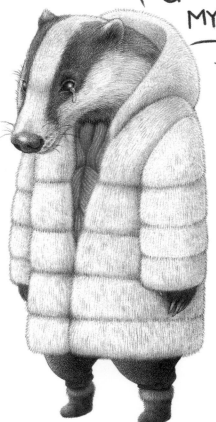

冀民參茸海味店
Human Dried Seafood & Tonic Food

商 品 名 稱	備 考	數 量
Pilose Antler	Sika Deer / Red Deer	∞
總 額 Priceless	經手人	Human

[1]Velvet antler preparations are sold in traditional medicines and in some countries as a dietary supplement, the effects of which are not supported by research.

[2]To supply the deer velvet industry, farms are created where the deer spend their entire lives confined to small, barren pens, pacing repetitively creating frustration and severe psychological distress in these far-roaming species.

[3]The deer are subject to a gruesome procedure to remove their antlers. After an injection in an attempt to sedate them, the horns are cut by hand but with some animals still semi-conscious.

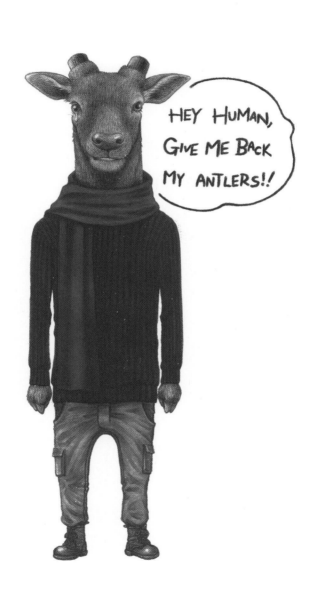

罟 民 藥 房
HUMAN PHARMACY

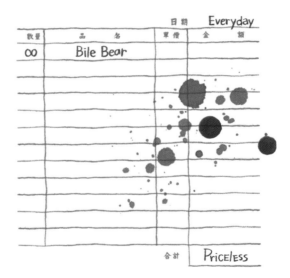

數量	品　名	單價	日期 Everyday 金　額
∞	Bile Bear		
		合計	Priceless

[1]Bear bile has been an ingredient in traditional medicine for 3,000 years. It is also found in a number of products ranging from shampoo and wine to eye drops.

[2]In addition to products containing bile, whole gallbladders, paws (in soup or wine) along with pelts, claws, teeth and bones are all widely traded

[3]Most farmed bears are kept permanently in cages, sometimes so small that they are unable to turn around or stand on all fours. Some bears are caged as cubs and never released, with many kept caged for up to 30 years. Most farmed bears are starved and dehydrated with those who fail to produce bile simply left to starve to death in their cages.

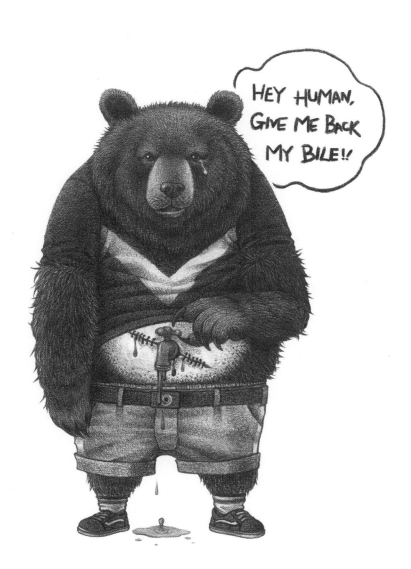

罟 民 藥 房
HUMAN PHARMACY

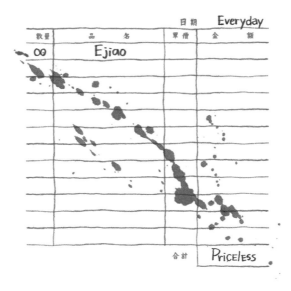

數量	品 名	日 期	Everyday	
		單 價	金 額	
00	Ejiao			
合計			Priceless	

[1]There are over 200 million working animals around the world being used as trucks, tractors and taxis.

[2]A PETA Asia investigation revealed that some donkeys are skinned alive in China so that their skins can be boiled down to make donkey-skin gelatin used in a Chinese 'medicine' called ejiao, found in vitamin, herbal and acupuncture stores as well as herbal teas, beauty products, candy and energy drinks.

[3]Donkeys are abused at live animal markets in Asia. Some restaurants offer fresh donkey meat where pieces of donkey are sliced off while the donkey is still alive.

[4]Approximately 4.8m donkeys are slaughtered for their skins every year. The slaughter methods are often unregulated, inhumane and unsanitary and large numbers die even on their way to the slaughterhouses.

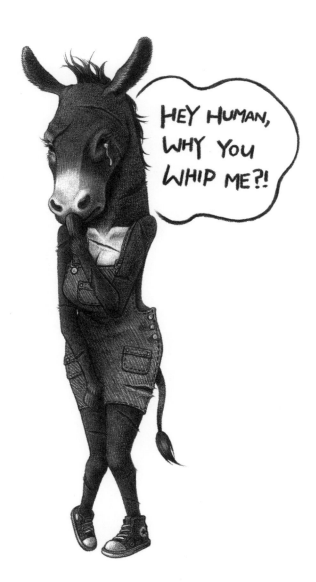

罵 民 藥 房
HUMAN PHARMACY

數量	品　　名	日 期　Everyday	
		單 價	金　　額
∞	Pangolin Scales		
		合 計　Priceless	

[1]The Pangolin is a gentle, solitary animal and is dubbed the world's most trafficked mammal, it's traded both for it's meat and scales. Around 100,000 are taken from the wild in Africa and Asia each year, driving a silent extinction.

[2]It is estimated that over 1 million pangolins have been killed in the past 15 years.

[3]All 8 species of pangolin are feaured on the IUCN Red List of Threatened Species, on par with rhinos and tigers.

[4]Pangolin is derived from the Malay word 'pengguling' which loosely translates to 'something that rolls up'.

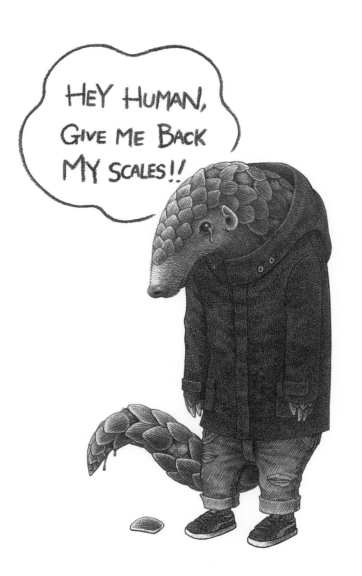

罷民參茸海味店

Human Dried Seafood & Tonic Food

商　品　名　稱	備　考	數　量
Shark Fin		∞

總　額	Priceless	經手人	Human

[1]Since the 1970s there has been a 71% decline in shark and ray species.

[2]73 to 100 million sharks are killed annually worldwide just for their fins, which are used as an ingredient of shark fin soup. The fins are sliced off and the living mutilated shark is tossed back into the sea to sink and slowly die.

[3]Sharks are hunted for other products such as meat, leather and health supplements in addition to their fins.

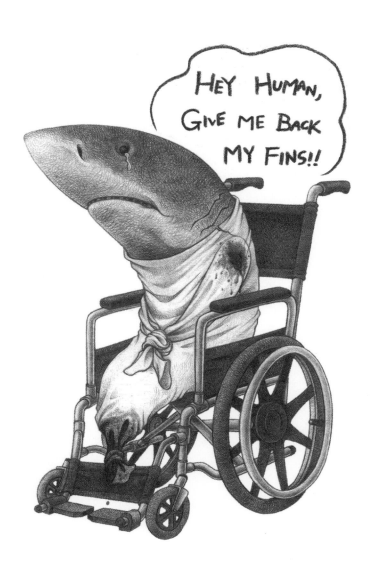

[1]24 of the 31 oceanic shark and ray species are now listed as either endangered or critically endangered by the International Union for Conservation of Nature.

[2]Sharks are apex predators and play a vital role in maintaining marine ecosystems. Without them, marine animals and habitats would suffer.

[3]Not only do humans decimate shark populations, but sharks have low reproductive rates, making repopulation difficult.

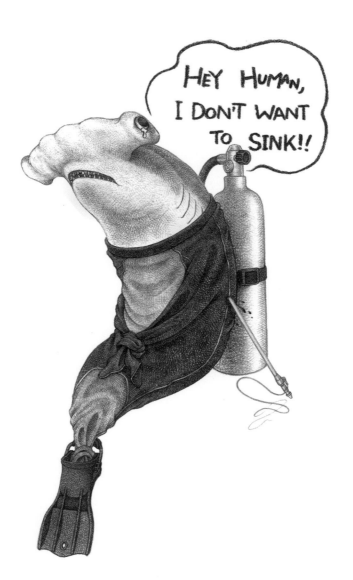

[1]An estimated 300,000 whales, dolphins and porpoises die after being injured in nets or lines designed to target other species.

[2]Commercial whaling was banned in 1986. However Japan, Norway and Iceland have killed nearly 40,000 large whales since then.

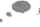

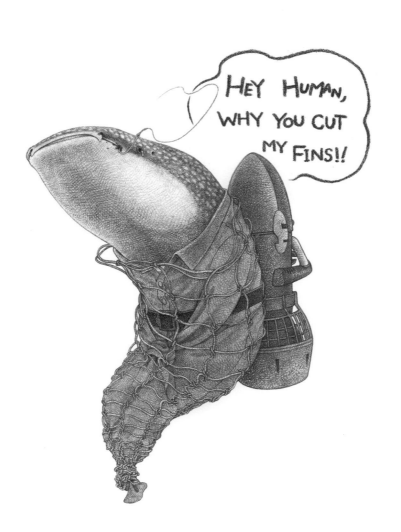

```
              HUMAN
           SUPERMARKET
            All the time
----------------------------------------
DATE  Everyday              No: Uncountable
----------------------------------------
ITEM              QTY          AMOUNT
----------------------------------------
1  Foie Gras         ∞

----------------------------------------
Total Amount :                  Priceless
                            ----------------

----------------------------------------
User Name : Human
System Name : Human-PC
         THANK YOU ! VISIT AGAIN !
```

[1]It's estimated that between 10 million and 70 million ducks and geese are force-fed to produce foie gras in the EU each year. Foie gras in French translates as 'fatty liver'.

[2]Workers ram pipes down the throats of male ducks twice each day, pumping up to 2.2 pounds of grain and fat into their stomachs. The force-feeding causes the birds' livers to swell to up to 10 times their normal size.

[3]The birds are kept in tiny cages or crowded sheds. Unable to bathe or groom themselves, they become coated with excrement mixed with the oils that would normally protect their feathers from water.

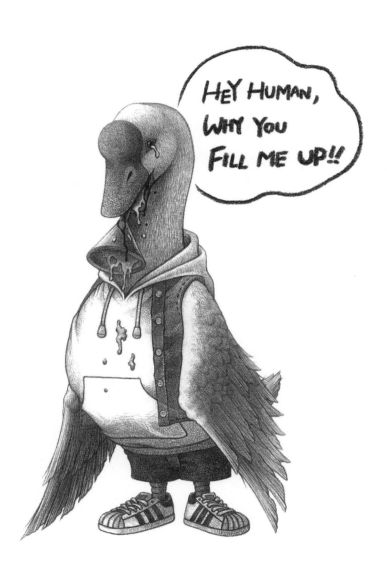

囂 民 野 味 小 菜

Human Wild Game Meat Restaurant

枱號 Uncountable 經手人 Human

數 量	項 目	總 額
∞	Wild Game Meat	
	合 計	Priceless

№ Uncountable

[1]Bats both dead and alive are on sale to be used for food, traditional medicine or entertainment or to be exploited in other ways.

[2]Unlike humans, bats can harbor diseases without becoming sick because they have a natural immunity. In fact, bats are natural reservoirs for more than 60 viruses that (although rarely) can infect humans such as Ebola, rabies, and Histoplasmosis. However, it's the way humans are treating bats that is allowing these diseases to spread. For example, humans are hunting and eating bats.

HUMAN CAFE

No: Uncountable
Twenty Four Seven
Drawer: Every Reg: Uncountable

Civet Coffee
XXXXXXXXXXXX

Total **Priceless**

---------- Check Closed ------------
Now

Have you tried the
new civet coffee?
To learn more go to
[f][o] : Milk DoNg Comics

[1]Kopi luwak is made from the beans of coffee berries that have been eaten, partially
digested and then excreted by the Asian palm civet.

[2]Civets are often captured in the wild and locked up in small, barren, filthy cages. They're
deprived of everything that's essential to their well-being, including exercise and a
spacious, natural environment.

[3]Many civets are held in civet farms, where the small, mongoose-like creatures are held in
battery cage conditions to produce the coffee.

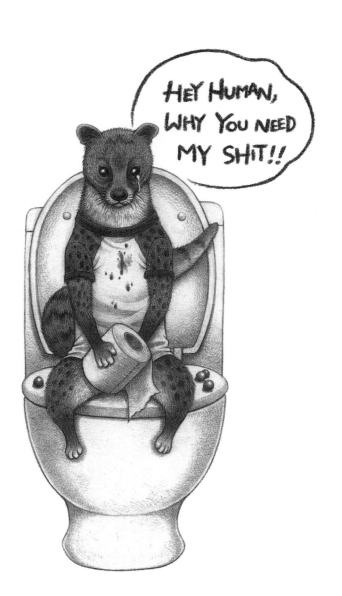

[1]A report by the Animal Welfare Institute (AWI), Pro Wildlife and Whale and Dolphin Conservation (WDC) concluded that more than 100,000 dolphins, small whales and porpoises (small cetaceans) are slaughtered globally in hunts each year - many to be used as fishing bait.

[2]Dolphin hunts are incredibly cruel, with animals killed using rudimentary methods including harpoons, knives, machetes, nets, spears and even dynamite. Death does not come quickly or painlessly. (Nicola Hodgins, small cetacean work lead at WDC).

[3]Since 1986, over 25,000 whales have been murdered legally for "scientific research." From 1904 to 1987, an estimated 1,339,232 whales were killed by commercial whaling fleets in the Antarctic alone. That's a heart wrenching 16,000 whales murdered year after year for the best part of a century.

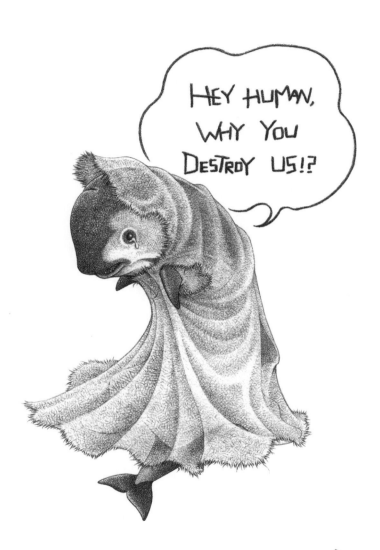

[1]According to the UN, almost 90% of global marine fish stocks are fully exploited, overexploited or depleted.

[2]Penguins suffer as a result of toxic plastics, resource competition, habitat destruction and encroaching of invasive species.

[3]Overfishing in some areas has led to a collapse of nutritious sardine stocks, forcing penguins to eat substitute food - low in fat and the penguin equivalent of junk food.

[4]A 2015 seabird study warned that at current rates of plastic production and pollution, 99.8 percent of the 186 species included in the report would be chowing down on plastic trash by mid-century.

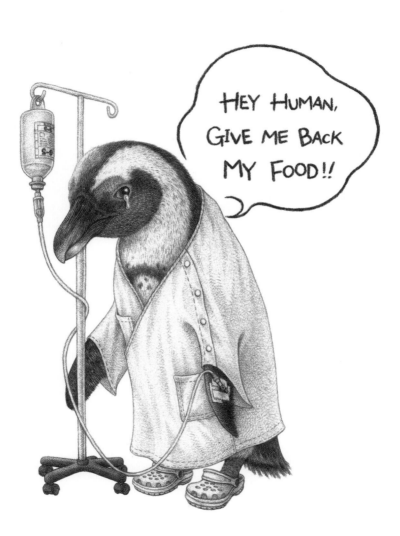

HUMAN FARM STORE

Everywhere

Date __Everyday__

No. __Uncountable__

Purchaser __Human__

1	Pesticide	∞	PriceLess
2			
3			
4			
5			
6			
7			
8			
9			
10			
11			
12			
13			
14			
15			

[1]Pesticides can harm bees both as larvae and adults. They disrupt learning and memory in honey bees and impair their reproduction.

[2]Exposure to pesticides can also compound the effects of other stressors on pollinator populations, such as loss of habitat and exposure to pathogens and diseases.

[3] More than 90% of pollen samples from bee hives in agricultural landscapes and more than 90% of stream samples are contaminated with more than one pesticide.

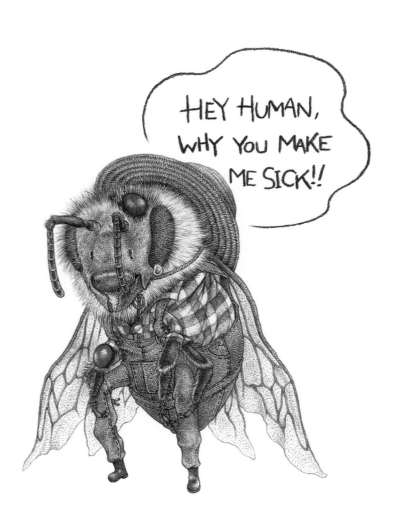

罵民國貨有限公司
Human Products Co., Ltd.

№ Uncountable　　　門　市　發　票　　　Everyday
　　　　　　　　　　　　　　　　年　月　　　日

貨　　號	貨　　　名	數　量	單　價	金　　額
	Rhino Horn			
	Craft	∞		
貨物出門 恕不退換	售貨員：Human		合　計	PricelEss

[1]Since 2008 11,690 rhinos have been poached in Africa.

[2]Rhinos once roamed many places throughout Europe, Asia, and Africa. At the beginning of the 20th century, 500,000 rhinos roamed Africa and Asia. By 1970, rhino numbers dropped to 70,000, and today, only around 27,000 rhinos remain in the wild.

[3]In 2022 448 rhinos were killed in South Africa. From 2007-2014 the country experienced an exponential rise in rhino poaching – a growth of more than 9,000%. In the last decade, 9,396 African rhinos have been lost to poaching.

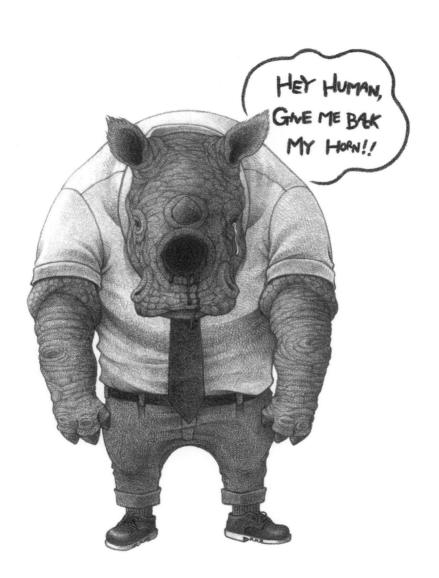

罷民國貨有限公司
Human Products Co., Ltd.

№ Uncountable 門 市 發 票 Everyday

年 月 日

貨　號	貨　　名	數　量	單　價	金　額
	Ivory Craft	∞		

貨物出門
恕不退換

售貨員：Human

合　計　　Priceless

[1] At least 20,000 African elephants are killed illegally for their ivory each year.

[2] Globally the ivory trade is estimated to be worth $23 billion per year.

[3] Poachers are increasingly using more and more barbaric methods of killing the animals. Arrows and spears with poisoned tips are used to slowly kill them. As these methods often prove ineffective the elephant tusks are cut out while they are still alive, leaving the animals to suffer a prolonged and excruciating death.

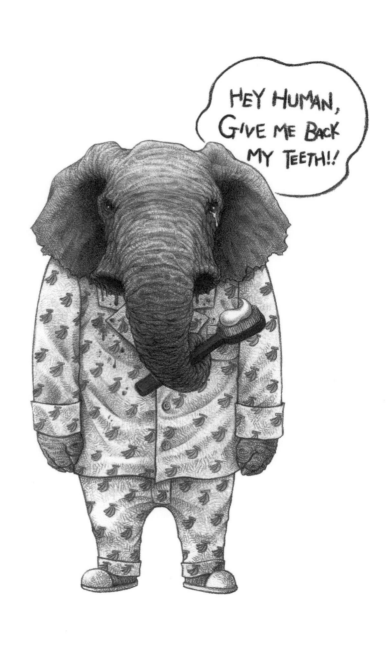

PLAZA DE TOROS DE HUMAN

TENDIDO	SILLON	NUMERO	PUERTA
ANY	ANY	ANY	ANY
FECHA	TIPO DE FESTEJO		PRECIO
EVERYDAY	BULL FIGHTING		PRICELESS

[1]Every year approximately 180,000 bulls are killed in bullfights with many more killed and injured during fiesta events.

[2]The bulls suffer a protracted death in the bullfighting arena, they are weakened and tormented both physically and mentally firstly with spiked lances, before the matador enters the ring and stabs them to death with a sword.

[3]There are only a few countries throughout the world where bullfighting still takes place including Spain, France, Portugal, Mexico, Colombia, Venezuela, Peru and Ecuador.

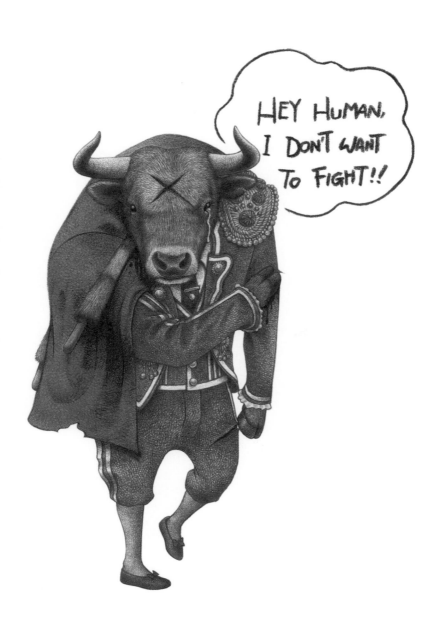

Human Horse Race Betting Limited

Validity of tickets is everyday

WIN
Every Race
Anyone

Unit Bet Priceless
Total **Priceless**
Everywhere Everyday

Uncountable
Uncountable

UNCOUNTABLE

HUMAN JOCKEY CLUB

HUMAN JOCKEY CLUB

HUMAN JOCKEY CLUB

[1]A study of injuries at racetracks concluded that one horse in every 22 sustained an injury that prevented him or her from finishing the race, while another study found that 3 thoroughbreds die every day at North American racetracks through injury.

[2]When their racing careers are over many horses end up at slaughterhouses where they are turned into dog food and glue.

[3]Whips are routinely used in horseracing, inflicting pain, trauma and tissue damage although there's no evidence that whipping a horse has any effect on performance. Tongue ties and spurs are also two common types of equipment used which cause discomfort and pain. Tongue ties are cords wrapped around the horses tongue and tied to their lower jaw while spurs are small spiked metal wheels attached to the jockeys boots.

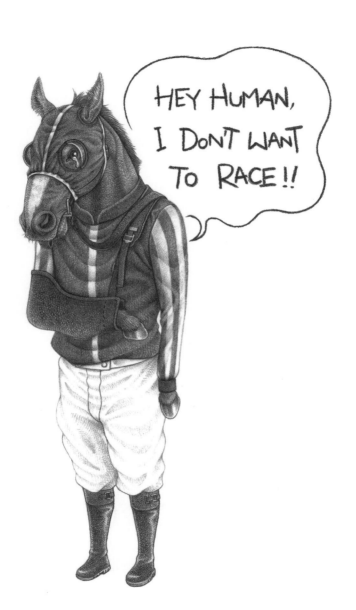

Colorful Painted Turtle

Capsule Toy

[1]Painting a turtle's shell can have a devastating effect on their well-being. It can hinder their ability to absorb the vitamins that they need from the sun, it can also cause respiratory problems and allow toxic chemicals into their bloodstream.

[2]Florida Fish and Wildlife points out that painted tortoises and terrapins are more visible to predators so consequently they become more vulnerable.

[3]Markets in Asia have been known to sell spray-painted turtles. "If you paint a thick layer of paint on their shells, it will stop the absorption of UV and then the formation of vitamin D process will be affected. So it will eventually affect the growth of the turtle and it will die." Dr Michelle Cheung, science manager at the ECO Education and Resources Centre.

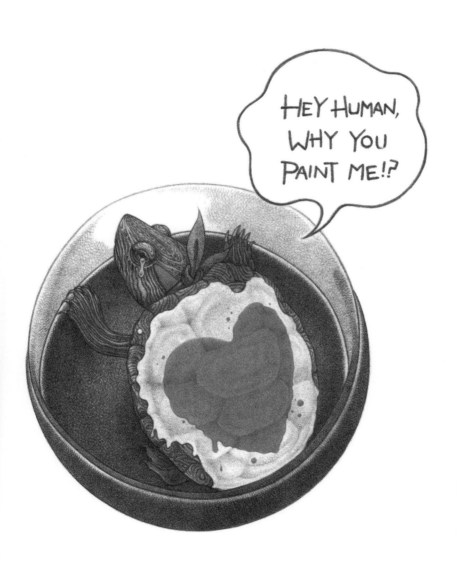

HUMAN FIREWORKS SHOP

Invoice Uncountable
Date Everyday

Item	Qty	Price
Firework	∞	
Firecracker	∞	
	TOTAL	Priceless

Thanks for your business.

[1]Fireworks can emit sounds up to 190 decibels, human hearing can be damaged by sounds above 75-80 decibels,

[2]The noises caused by fireworks can cause stress and even death by fright in birds as well as disorientation and panic.

[3]Fireworks can cause flocks of birds to take off for prolonged periods of time, expending crucial energy, and even fly so far out to sea that they are too exhausted to make the return flight. Additionally the debris from fireworks, containing toxic materials, can be mistakenly consumed by wildlife or even fed to their young.

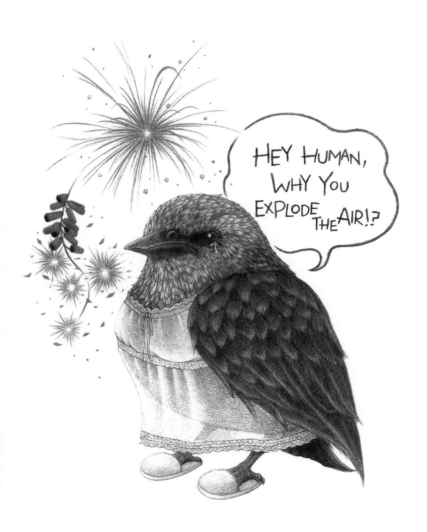

NOT EVERY HOME
 NEEDS A PET,

BUT EVERY PET
 NEEDS A HOME!!

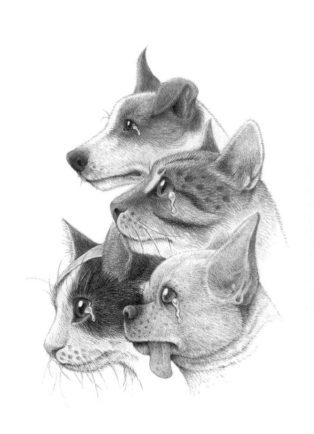

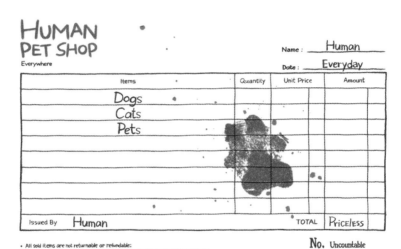

HUMAN
PET SHOP
Everywhere

Name : __Human__

Date : __Everyday__

Items		Quantity	Unit Price	Amount	
Dogs					
Cats					
Pets					
Issued By Human				TOTAL	Priceless

No. Uncountable

- All sold items are not returnable or refundable;
- Any deposits on dogs, cats and pets are only valid for a few days from the date of purchase;
- All sold items are entitled to a few days health guarantee period. Should the customers revealed that there are any health problems in respect of the above items within the prescribed period, please bring them back to us for consultation. Please note that no claims will be granted or accepted if the items have been taken to a vetinarian or have been given any medicine by the customer.
- Our shop reserves all the rights to amend the above terms and conditions.

[1]Puppy mills are commercial facilities that mass produce dogs for sale in pet stores. Roughly 90 percent of puppies in pet stores come from puppy mills.

[2]In many states, these commercial breeding kennels can legally keep hundreds of dogs in cages their entire lives, for the sole purpose of continuously churning out puppies.

[3]Animals kept in puppy mills can be confined to squalid, overcrowded cages with minimal shelter, while some animals suffer from malnutrition and poor veterinary care.

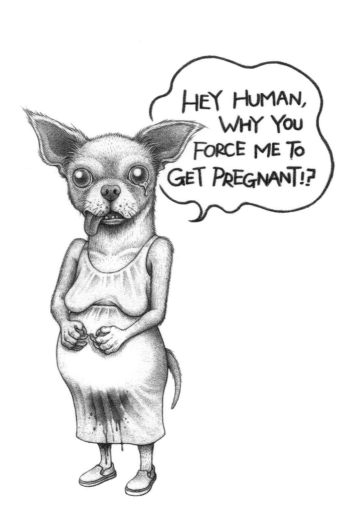

HVC
Human Veterinary Clinic

Human
Everywhere

Tax Invoice for Professional Services

Patient : CATs

Details On Everyday
Declaw Surgery

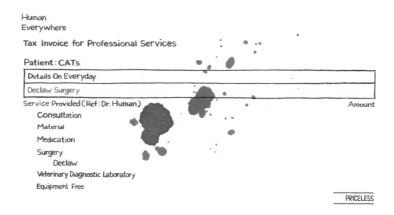

Service Provided (Ref: Dr. Human)	Amount
Consultation	
Material	
Medication	
Surgery	
Declaw	
Veterinary Diagnostic Laboratory	
Equipment Free	

PRICELESS

Ref Uncountable - Twenty four seven

To ensure optimum quality of drugs, medication dispensed cannot be returned for refund.

Prepared by: Human
HVC
Everywhere

[1]Declawing is a violent and painful mutilation involving 10 separate amputations of both the cat's nails and their joints. They can find themselves in extreme pain after the operation and can struggle to walk until their wounds heal.

[2]The long term effects of removing a cat's nails can include skin and bladder problems, over time weakening their legs, shoulders and back muscles.

[3]There are also severe psychological effects on the cat including neuroses and paranoia. In addition, they can also become prey to other animals when outdoors as they are virtually defenseless.

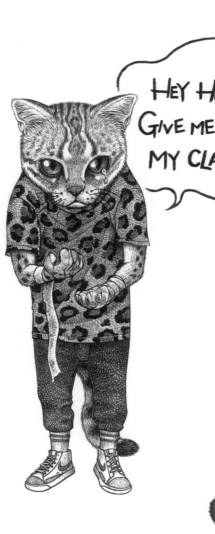

CERTIFIED COPY OF AN ENTRY
Pursuant to the Births and Deaths Registration

DEATH	
Registration district Sub-district	Everywhere
Date and place of death	Everyday Everywhere

Name and surname	Sex
Stray / Abandoned Animal	Every

Date and place of birth	Everyday Everywhere
Occupation and usual address	Everywhere
Cause of death	Euthanasia

I certify that the particulars given by me above are true to the best of my knowledge and belief.

Human

Date of registration	Signature of registrar
Everyday	Human

[1]In the USA alone, only 1 in 10 dogs born will find a permanent home. Each year approximately 2.7 million dogs and cats are killed each year because shelters are full and there are not enough adoptive homes.

[2]Approximately 7.6 million companion animals enter animal shelters in the USA every year. 3.9 million of these are dogs.

[3]Only 10% of the animals received by shelters have been spayed or neutered. There are about 3,500 brick-and-morter animals shelters in North America alone as well as 10,000 rescue groups and animal sanctuaries.

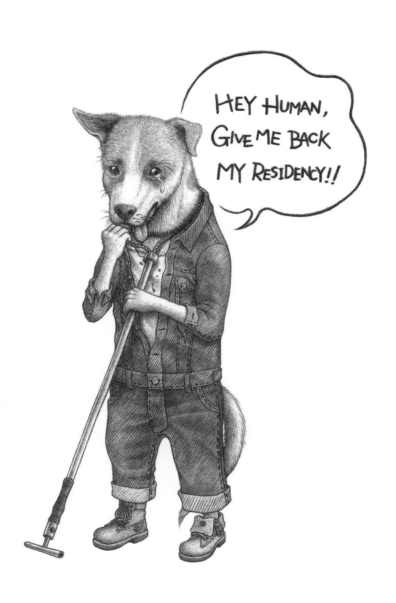

Injury Report			
Name: _Tramp_		Address: _Homeless_	

Incident

Date of Accident: _Everyday_ Time of Accident: _Twenty Four Seven_
How did the injury occur? _Attacked by human_
Witnesses: _Everyone_
Others Involved: _Everyone_
Caused by: _Attacked by human_

Injury

Description of Injury: _Dying_
Nature of Injury: ☑ Burn ☑ Cut ☑ Bruise ☑ Scrape ☑ Break ☑ Sprain ☑ Strain ☑ Concussion
Other: _____

Part(s) of Body Affected
☑ Left ☑ Right

☑ Foot	☑ Ankle	☑ Knee	☑ Shin
☑ Calf	☑ Thigh	☑ Buttocks	☑ Waist
☑ Hip	☑ Groin	☑ Stomach	☑ Ribs
☑ Chest	☑ Back	☑ Shoulder	☑ Neck
☑ Hand	☑ Wrist	☑ Forearm	☑ Elbow
☑ Bicep	☑ Head	☑ Forehead	☑ Ears
☑ Eyes	☑ Nose	☑ Mouth	☑ Chin

[1]Intentional cruelty to animals is strongly correlated with other crimes, including violence against people. In one survey, 71 % of domestic violence victims reported that their abuser also targeted pets.

[2]According to the National Council on Pet Population Study and Policy (NCPPSP), less than 2% of cats found on the streets are returned to their owners. Many are lost pets that were not kept properly indoors or provided with identification.

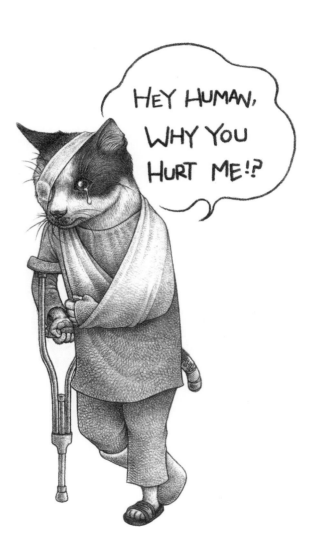

HUMAN
PET SHOP
Everywhere

Name : __Human__

Date : __Everyday__

Items	Quantity	Unit Price	Amount
Purebred Dogs			
Purebred Cats			
Purebred Pets			

Issued By __Human__

TOTAL __Priceless__

No. Uncountable

- All sold items are not returnable or refundable;
- Any deposits on dogs, cats and pets are only valid for a few days from the date of purchase;
- All sold items are entitled to a few days health guarantee period. Should the customers revealed that there are any health problems in respect of the above items within the prescribed period, please bring them back to us for consultation. Please note that no claims will be granted or accepted if the items have been taken to a vetinarian or have been given any medicine by the customer.
- Our shop reserves all the rights to amend the above terms and conditions.

[1]Inbreeding causes painful and even life-threatening genetic defects in 'purebred' dogs and cats, including crippling hip dysplasia, blindness, deafness, heart defects, skin problems and epilepsy.

[2]Animals can be distorted to exaggerate their physical features, which lead to back problems and breathing issues that make exercise almost impossible.

[3]Boxer dogs for instance according to research compiled by the Royal Veterinary College in London are genetically predisposed to 76 health conditions including musculoskeletal issues, eye ulcers, cancer and irritable bowel syndrome.

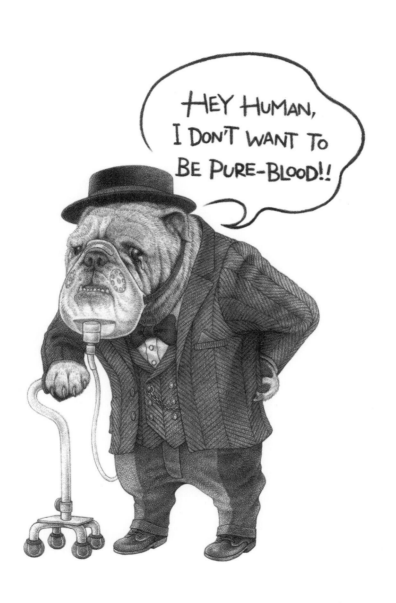

HUMAN
PET SHOP
Everywhere

Name : __Human__

Date : __Everyday__

Items	Quantity	Unit Price		Amount	
Pets					
	TOTAL	Priceless			

Issued By Human

No. Uncountable

- All sold items are not returnable or refundable;
- Any deposits on dogs, cats and pets are only valid for a few days from the date of purchase;
- All sold items are entitled to a few days health guarantee period. Should the customers revealed that there are any health problems in respect of the above items within the prescribed period, please bring them back to us for consultation. Please note that no claims will be granted or accepted if the items have been taken to a vetinarian or have been given any medicine by the customer.
- Our shop reserves all the rights to amend the above terms and conditions.

[1]Before the Wild Bird Conservation Act (WBCA) over 800,000 wild-caught birds were imported into the USA for the pet trade each year, this figure does not include the large number of birds that died during transportation. Despite this and the Endangered Species Act millions of wild birds are still illegally smuggled into the country each year.

[2]The Animal Law Coalition explains how parrots have been found hidden away in everything from toothpaste and toilet paper tubes as well as carried in glove compartments, tire wells and even hubcaps. The animals are drugged or given alcohol to keep them quiet during the trip or even have their beaks taped shut.

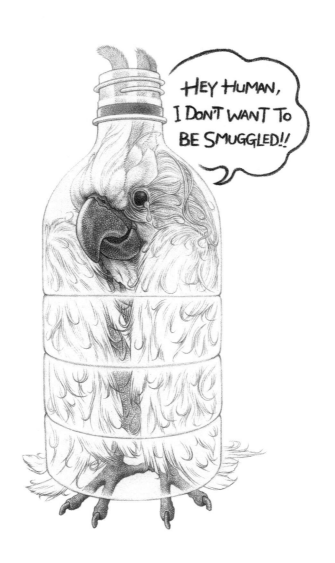

HUMAN
PET SHOP
Everywhere

Name : ___Human___

Date : ___Everyday___

Items	Quantity	Unit Price	Amount	
Pet Gift Box				

Issued By Human

TOTAL Priceless

No. Uncountable

- All sold items are not returnable or refundable;
- Any deposits on dogs, cats and pets are only valid for a few days from the date of purchase;
- All sold items are entitled to a few days health guarantee period. Should the customers revealed that there are any health problems in respect of the above items within the prescribed period, please bring them back to us for consultation. Please note that no claims will be granted or accepted if the items have been taken to a vetinarian or have been given any medicine by the customer.
- Our shop reserves all the rights to amend the above terms and conditions.

[1]Rabbits, birds, mice and other rodents sold in pet shops can come from mill-like breeding facilities, with thousands of animals confined to plastic bins stacked on shelving units.

[2]Happy rabbits who live indoors and are properly cared for can live for 12 years or more and are also happier and healthier when living with a compatible bunny. When left outside in hutches, they can suffer in extreme heat or cold, rain, or snow.

[3]Animals purchased at a pet store or from a breeder will be replaced by another one, perpetuating the cycle of abuse and preventing bunnies already in shelters awaiting adoption from being adopted.

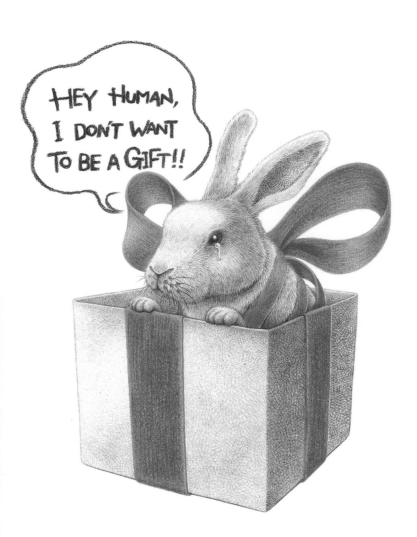

[1]Pony was a six or seven year old female orangutan who was rescued from a brothel in Borneo in 2003. She was found chained to a wall, lying on a mattress. Her hair had been completely shaved off and she was covered in mosquito bites. Pony was found wearing rings and necklaces and was being used as a prostitute. It took over a year and 35 policemen armed with AK-47s and other weaponry to be able to rescue Pony as the villagers would not give her up.

[2]After she was rescued Pony was taken to a rehabilitation Centre in Nyaru Menteng in Central Kalimantan.

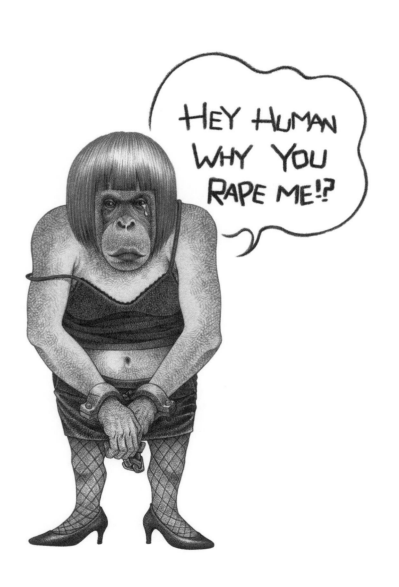

[1]Captive elephants can be forced to live in artificial social units consisting of only two or three animals, or in some cases even kept alone. Elephants in the wild usually live in large family units, sometimes with as many as 100 members. Any type of bond that the animals make during captivity is usually broken as they shuffle between zoos and circuses.

[2]In the wild, elephants can walk up to 40 miles a day as constant exercise is crucial to their health. Captive animals therefore suffer the effects caused by inadequate exercise and this can prove deadly. Sometimes chained and forced to live in small enclosures exacerbate their lack of exercise, causing arthritis, abscesses and other chronic foot and joint problems.

[3]Wild elephants typically live between 60 and 70 years. Elephants in captivity can be routinely beaten, shocked and kept chained for long periods and are not usually expected to live beyond the age of 40.

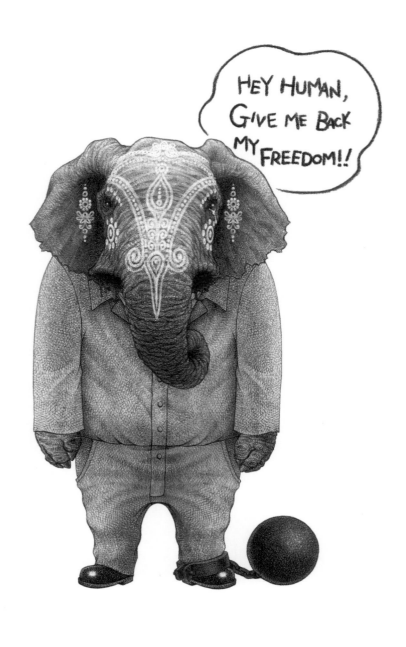

HUMAN

Convenience Store
Everywhere

RECEIPT

Description	Price
Monkey Nuts	
Sliced Bread	

Total	Priceless

THANK YOU!

[1]Monkeys are highly susceptible to diseases spread through bacteria from human hands during feeding. This feeding increases their migration to human populated areas.

[2]The irregular feeding patterns that monkeys are faced with leads to aggressive behavior towards humans and other species. When receiving food from a human the monkey is conditioned to assume the next time they see a person with food that they are going to get some. In the wild monkeys can travel an average of 17 kilometers each day, consequantly their dependency on human feeding has a negative effect on their overall physical health.

[3]Feeding monkeys creates a dangerous dependency on humans that diminishes the monkey's ability to survive and disrupts their natural ability to find food in the wild. Their natural diet of wild fruits, seeds, small animals and insects is disrupted, negatively impacting their lifestyle and how they interact naturally with their environment.

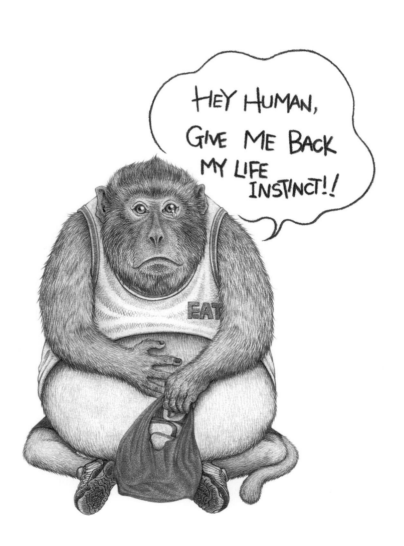

HUMAN TRAVEL

INVOICE

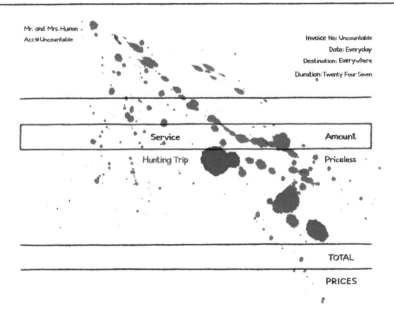

Mr. and Mrs. Human
Acc # Uncountable

Invoice No: Uncountable
Date: Everyday
Destination: Everywhere
Duration: Twenty Four Seven

Service	Amount
Hunting Trip	Priceless

TOTAL

PRICES

[1]1,200 species are hunted and killed as trophies including Africa's 'big five' species: Buffalo, Elephant, Leopard, Lion and Rhino.

[2]On average the USA imports more than 126,000 animal trophies per year.

[3]In canned hunts, animals are held within an enclosure. Across South Africa as many as 8,000 lions are held in more than 200 captive breeding facilities, many languishing in appalling conditions. The ultimate fate for many of these unfortunate animals is to be shot by 'sports hunters' with bones and other body parts exported for 'traditional medicines'.

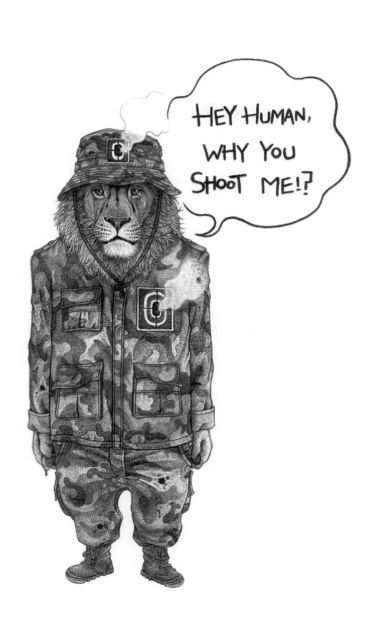

HUMAN TRAVEL

INVOICE

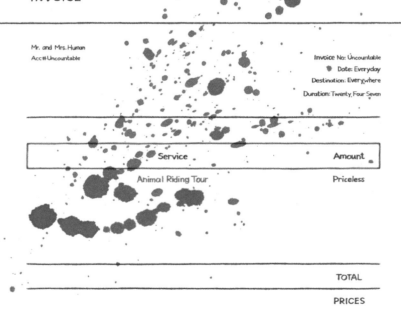

Mr. and Mrs. Human
Acc#Uncountable

Invoice No: Uncountable
Date: Everyday
Destination: Everywhere
Duration: Twenty, Four Seven

Service	Amount
Animal Riding Tour	Priceless

	TOTAL
	PRICES

[1]In Birqash Camel Market, (the chief supplier of camels to the Egyptian tourism industry) men repeatedly whip and hit animals, their legs tied tightly together to prevent them moving or escaping, with some camels tied to the backs of vehicles and dragged through the dirt. When their bodies are too worn out to be used as human rides they can be sold to be killed for meat.

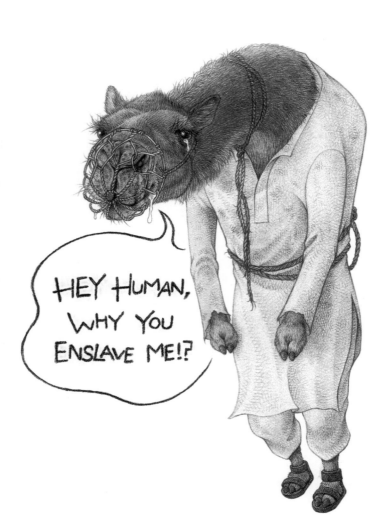

[1]Baby elephants are taken from their mothers and families in the wild illegally, their protective mothers are often killed as they try to save them. Once in captivity the babies are beaten to inflict pain until their spirits are broken and they're willing to obey their 'trainers' to avoid the pain. This often leads to post-traumatic stress disorder.

[2]All three species of elephant are listed on the International Union for Conservation of Nature (IUCN) Red list of threatened species as 'Endangered' or 'Critically Endangered'

[3]It's estimated that as many as 75% of captive adult elephants used for tourist entertainment across Asia have been captured from the wild.

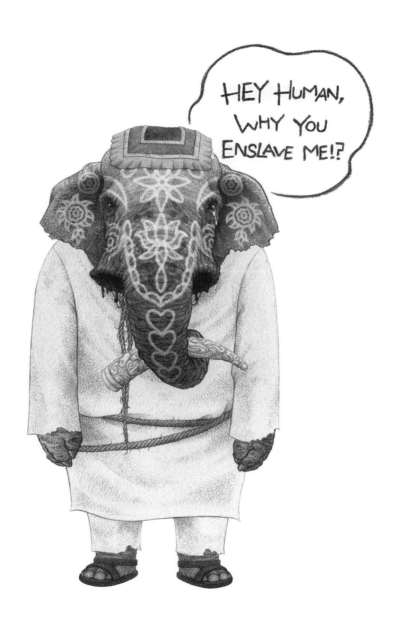

YOU ARE GOING TO

HUMAN ZOO!

A DAY AT THE
HUMAN ZOO

NO.
Uncountable

NAME
Human

DATE
Everyday

BE READY BY
Human

[1]Panda habitat continues to shrink to the point where the few survivors are driven into tiny, fragmented pockets of land, surrounded by relentless industrial development and invaded by crass, noisy tourists. Some of the survivors have actually been captured and put to work in the breeding factories.

[2]Zoos cannot provide the amount of space that animals have in the world. This is particularly important for animals which roam larger distances in their natural habitat. Tigers and lions have approximately 18,000 less space in a zoo than they would have in the wild and Polar Bears have one million times less space.

[3]A Freedom on Animals study found that at least 7,500 and possibly as many as 200,000 animals were 'surplus' at any one time in European zoos.

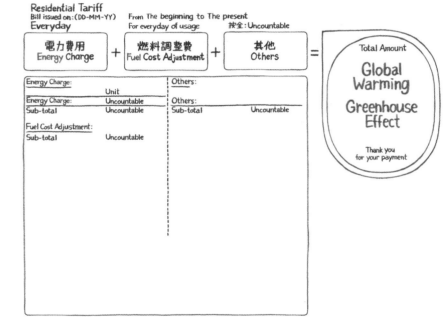

罷民電力有限公司
Human Power Limited

HUMAN
Everywhere

Residential Tariff
Bill issued on: (DD-MM-YY)
Everyday

From The beginning to The present
For everyday of usage 按金: Uncountable

| 電力費用 Energy Charge | + | 燃料調整費 Fuel Cost Adjustment | + | 其他 Others | = | Total Amount |

Global Warming Greenhouse Effect

Thank you for your payment

Energy Charge:		Others:	
Energy Charge:	Unit		
	Uncountable	Others:	
Sub-total	Uncountable	Sub-total	Uncountable
Fuel Cost Adjustment:			
Sub-total	Uncountable		

[1]Southern range sea ice is melting earlier in spring and forming later in autumn. Bears are spending longer periods without food leading to a decline in their health. This can lead to lower reproduction rates, higher cub mortality – and eventually, local extinction. The main causes of death for cubs are lack of food or lack of fat on nursing mothers.

[2]Polar bears are exposed to high levels of pollutants through their food as the Arctic food chain contains high levels of some toxic chemicals.

[3]According to World Wildlife Fund, the Arctic is heating up at a rapid rate – twice as fast as any other region and causing Arctic sea ice to melt. This is resulting in polar bears losing their habitats at a rate of 14% per decade. According to the Centre for Biological Diversity, 2/3 of polar bear populations could be extinct by 2050 due to greenhouse gas emissions and global warming.

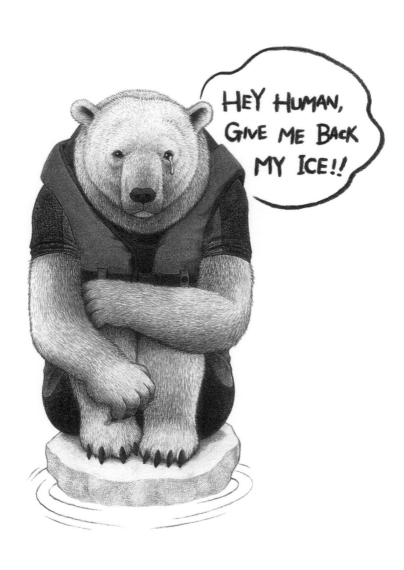

[1]On 20 April 2010, the drilling rig Deepwater Horizon exploded after a surge of natural gas blasted through its concrete core, spilling 795 million litres (210 million gallons) of crude oil into the Gulf of Mexico, off the coast of Louisiana. Somewhere between 100,000 and a million birds were killed outright.. Audubon Delta estimates 10% of all the brown pelicans in the northern Gulf of Mexico died because of the oil spill.

[2]For the year 2022, there were seven spills worldwide. Three of the seven incidents resulted in spills greater than 700 tonnes (classified as 'large' spills). Two of these incidents occurred in Asia and one in Africa. They resulted in the release of crude, bitumen and fuel oil into the marine environment. The four other incidents, classified as 'medium' spills, involved spills of fuel oil and diesel. The total volume of oil lost to the environment from tanker spills in 2022 was approximately 15,000 tonnes; more than 14,000 tonnes of which was lost in the three large incidents.

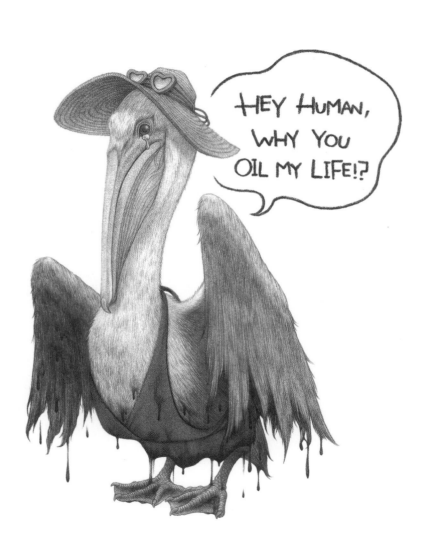

[1]A UK study found that at least nine out of ten of the aquariums surveyed had animals displaying 'abnormal' behaviours, which can include circling, head-bobbing, spiralling swimming patterns and repeatedly touching glass barriers. Sharks and rays in particular were observed performing 'surface breaking behaviours', which are not known to be part of the normal range of natural or wild behaviour of these species.

[2]Seventy orcas have been born in captivity around the world since 1977 (not counting another 30 that were stillborn or died in utero) according to records in two databases maintained by cetacean experts. Thirty-seven of them are now dead. In the wild orcas can be expected to live into their 50s and some possibly as old as 80. Only a handful of wild-caught orcas have lived past age 30. No captive-born orca yet has.

[3]Orcas have the second largest brain of any animal on the planet. Like humans, their brains are highly developed in the areas of social intelligence, language and self-awareness. In the wild, orcas can be expected to live in tight-knit family groups that share a sophisticated, unique culture that is passed down through generations, research has shown.

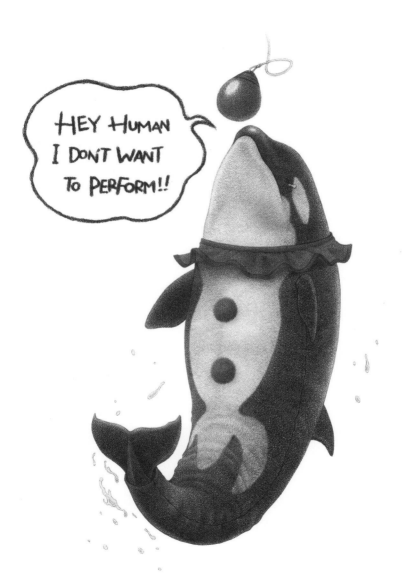

¹In 1916 Mary the Elephant, a circus performer who could play musical instruments, catch baseballs and even stand on her head was arrested and hung from an enormous crane until she was pronounced dead after she had been found guilty of murder.

²Despite claims by circuses and zoos that the 'tricks' they perform are based on natural behavior, in the wild elephants do not stand on their heads, balance or sit on stools, or walk only on their hind legs.

³Captive elephants have significantly lower life spans and can often be dead before the age of 40, they can also suffer from chronic health problems such as tuberculosis.

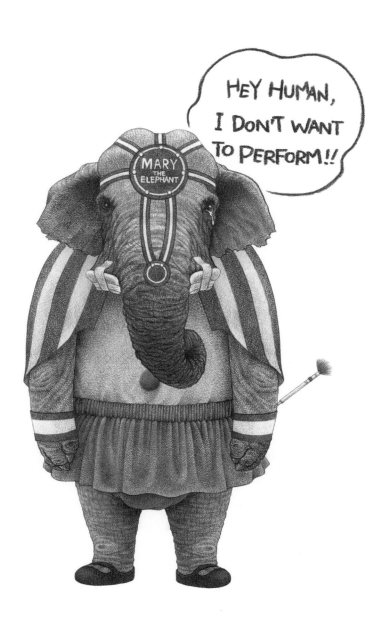

[1]Under Taoist beliefs, those who release caged animals back into the wild are supposed to receive good fortune. Over 200 red-eared slider turtles were rescued after a misguided group threw the freshwater creatures into the sea which could have been fatal.

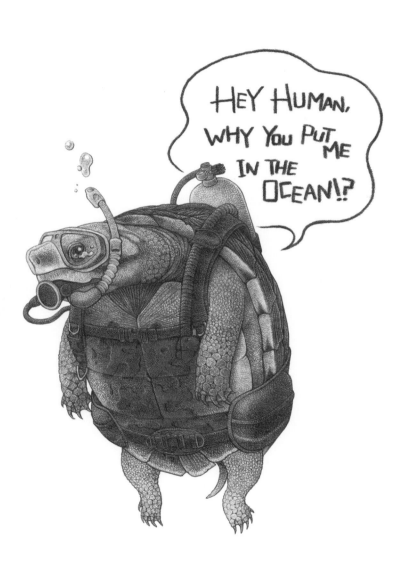

Humangas

HUMAN
EVERYWHERE

Bill information			
Previous bill amount		Uncountable	charge
Balance brought forward		Uncountable	Uncountable

From The beginning to The present	1 unit = 48 MJ	Consumption (MJ)
This consumption is estimated. Please report meter reading.		

Standard gas charge		Uncountable	
Fuel cost adjustment		Uncountable	
Monthly maintenance charge		Uncountable	charge
		Uncountable	Uncountable
			Other
			charges
Spare parts			Uncountable

Total bill amount		Global Warming	Please pay
		Greenhouse Effect	Priceless

Environmental Information – CO₂ emission per MJ of town gas: 0.065kg

[1]Walruses spend most of their time on sea ice. They migrate with moving ice floes and need ice for rest between dives for food. Due to climate change the sea ice is dramatically shrinking requiring the Walruses to swim much farther distances to land when there is no sea ice available.

[2]These commutes to shore can be more than 100 miles and often young calves do not survive the journey. The Arctic is warming twice as fast as the rest of the planet and if emissions continue to rise unchecked, it could be ice-free in the summer as early as 2040.

[3]Walruses are highly susceptible to disturbance and noise. During their mass gatherings, stampedes can occur as easily spooked walruses attempt to reach the water.

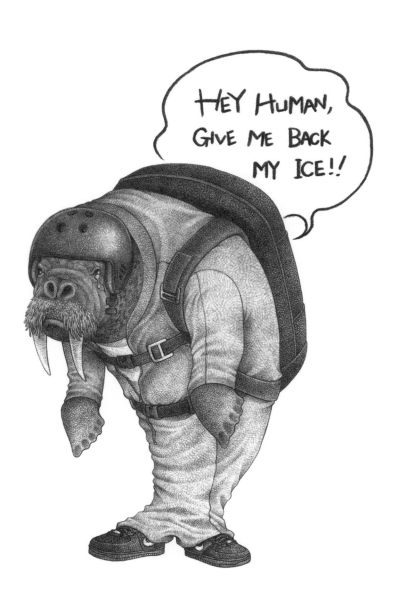

[1]Turtles like a dark beach to nest, but artificial shore light can discourage the female from nesting, after multiple false crawls she will resort to less-than-optimal nesting spots or deposit her eggs in the ocean. In either case, the survival outlook for hatchlings is slim.

[2]Lighting near the shore can also cause hatchlings to become disoriented and wander inland, where they often die of dehydration or predation.

[3]An estimated one third of all lighting in the U.S. is wasted. With an annual expenditure of about 30 million barrels of oil and 2 million tons of coal on unnecessary lights, the cost of the wasted lighting equals about $2 billion each year.

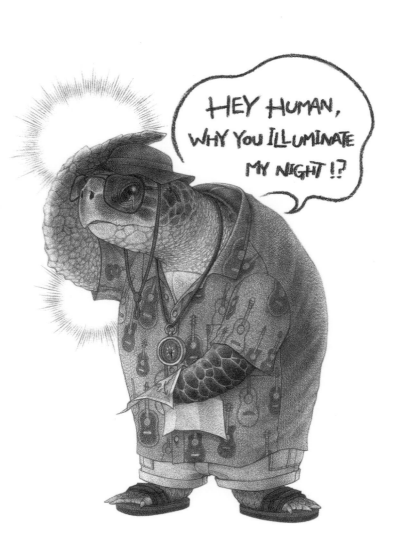

[1]Government statistics show that approximately 45% of belugas have died after five to seven years in captivity (the average life span for a beluga in the wild ranges from twenty five to fifty years).

[2]Belugas are held in marine parks and aquaria in at least 10 different countries and there are thought to be well over 300 belugas in captivity. In the wild beluga whales lead highly social lives travelling in relatively large pods and switching between different groups on a regular basis.

[3]In their natural habitat beluga whales choose their own mates, often performing a form of dance as part of their courtship ritual. In captivity they are forcibly bred leading to conflict in cramped tanks. The inability to escape from other frustrated and aggressive animals has likely led to injuries and even death.

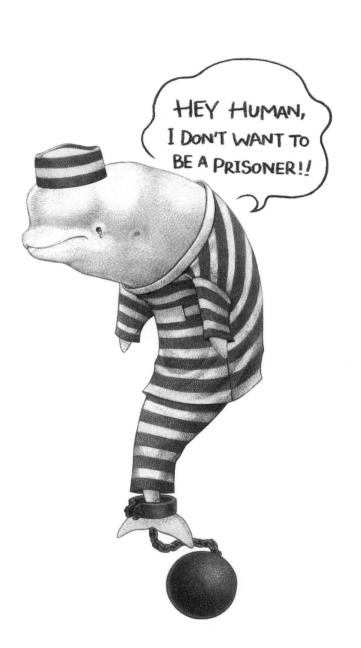

HUMAN

LAND DEVELOPMENT CORPORATION LTD.

Bill From
Name: Human
Everywhere

Bill To
Name: Human
Everywhere

CONSTRUCTION INVOICE
Invoice No: Uncountable
Date: Everyday

Description/Job Phase	Price
Deforestation	Priceless
Oil Extraction	Priceless
Mining	Priceless
Total	Priceless

Terms and Conditions

Thank you for your business. Please send payment ASAP.

[1]Forests are rapidly being destroyed by commercial logging interests, subsistence agriculture and road building activities making it harder for gorillas to sustain their lives.

[2]There is also a strong link between habitat loss and the bushmeat trade. As previously inaccessible forests are opened up by timber companies, commercial hunters gain access to areas where gorillas roam and often use logging vehicles to transport bushmeat to far away markets.

[3]Gorillas are also sought after as pets or trophies and for their body parts, which are used in medicine and as magical charms.

[4]Low reproductive rates means that even low levels of hunting can cause a population decline, which could take many generations to be reversed. Gorillas are also frequently maimed or killed by traps and snares intended for other forest animals such as antelopes.

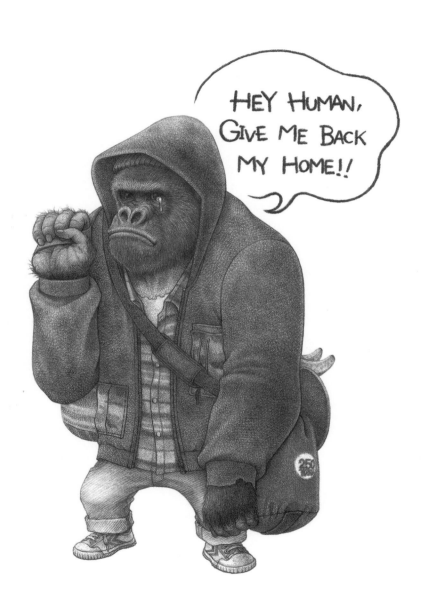

HUMAN
Logging and Timber

INVOICE

Bill From
Name: Human
Everywhere

Customer:

Bill To
Name: Human
Everywhere

Description	Quantly	Price
Wood	Uncountable	Priceless
Total:		Priceless

We will be happy to supply any further information you may need and trust that you call on us to fill your order, which will receive our prompt and careful attention.

Signature: *Human*
Date: Everyday

Thank You For Your Business!

[1]Most of the Tarsier species and subspecies are designated as threatened with the exception of the Philippine subspecies.

[2]For the Western Tarsiers 30% of their habitat has been lost over the last 20 years, this is in addition to the reduction in numbers due to risk of capture for the pet trade.

[3]Tarsiers face a number of threats, most notably habitat loss or degradation, with many tarsiers losing more than half of their original habitat. In some areas much of the forest has been converted to agricultural use. Forests are often destroyed for palm or coffee plantations, mining, logging for timber or turned into grazing land.

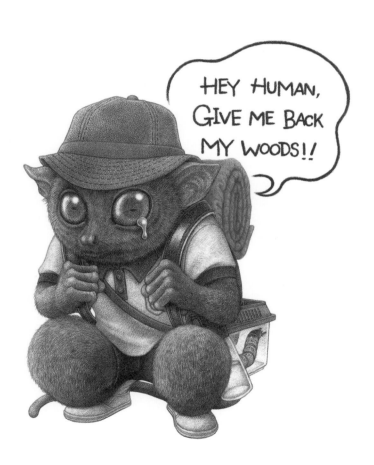

[1]The freshwater Amazon River Dolphin faces challenges from development projects. Dam construction fragments populations and limits the species' range and ability to breed.

[2]The Ganges River Dolphin is essentially blind and catches prey with echolocation, it faces threats from agriculture and river pollution, dam and blockade creation, irrigation canal construction as well as fishing.

[3]The Yangtze Finless Porpoise lives in the Yangtze River, the longest river in Asia and used to share the waters with the Baija (Yangtze River Dolphin) a species declared functionally extinct in 2006. Dredging, pollution and boat strikes from shipping and transportation threaten the porpoise.

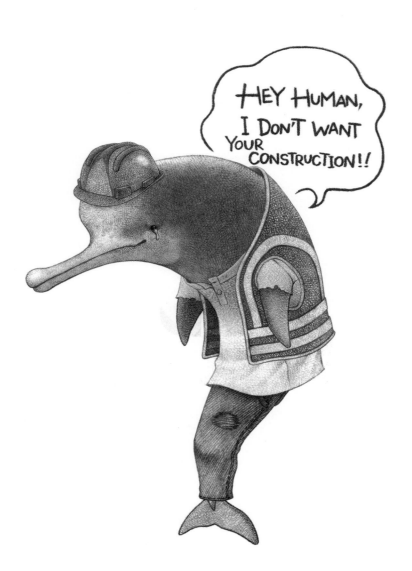

HUMAN FIREARMS

Firearm • Ammo • Tactical Supplies

QTY	ITEM	AMOUNT
∞	Animal trap	
∞	Shotgun	

			TOTAL	Priceless

Date: __Everyday__ No. Uncountable

Purchaser: __Human__

Thanks for shopping with us!

[1] In Hong Kong due to urbanization growth invading the pig's natural habitat combined with human feeding has meant that the local wild boar population have changed their diet. This has led to more wild boars entering urban areas for food. As a result authorities began a cull with a bait-and-kill approach.

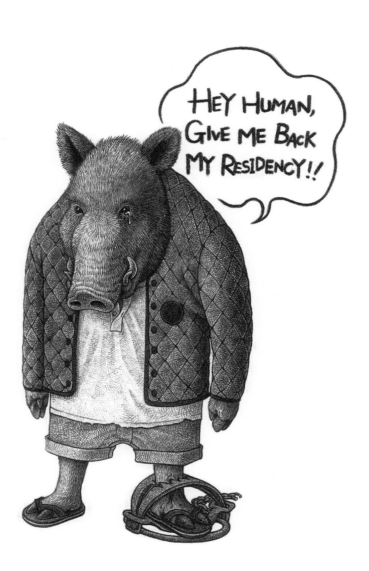

[1]Researchers found that ships and smaller craft hit at least 75 species - including dolphins, sharks, sea otters, seals, penguins and sea turtles. Among them are vulnerable species such as the critically endangered Kemp's ridley sea turtle and the endangered Hector's dolphin. Younger animals are particularly at risk, because they are more playful and less experienced and are often left alone while a parent forages for food.

[2]Every year over 100,000 dolphins and small whales are killed in hunts across the globe. While the hunts that take place in Japan and the Faroe Islands are well documented, hunts take place in other parts of the world on an almost daily basis.

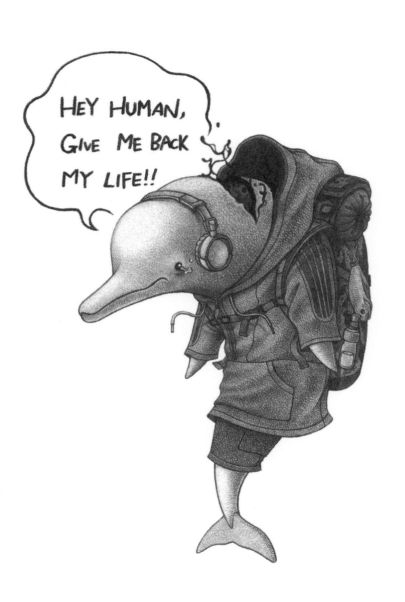

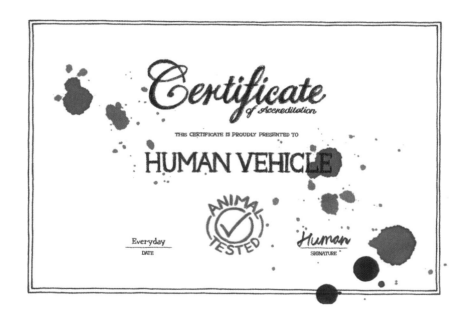

Certificate
of Accreditation

THIS CERTIFICATE IS PROUDLY PRESENTED TO

HUMAN VEHICLE

ANIMAL
TESTED

Everyday
DATE

Human
SIGNATURE

[1]Despite the use of advanced technology, computer modelling, 3-d medical imaging, virtual reality and sophisticated manikins for car-crash modelling live animals continue to be used for crash tests.

[2]Live pigs and dogs are used in tests that leave them with broken bones and severe internal injuries before they are killed and dissected.

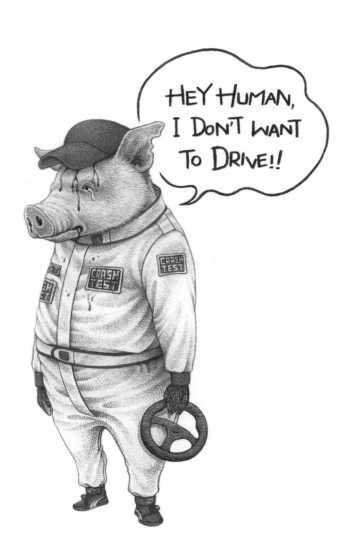

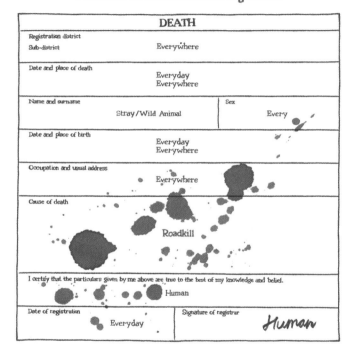

CERTIFIED COPY OF AN ENTRY
Pursuant to the Births and Deaths Registration

DEATH		
Registration district Sub-district	Everywhere	
Date and place of death	Everyday Everywhere	
Name and surname Stray/Wild Animal	Sex	Every
Date and place of birth	Everyday Everywhere	
Occupation and usual address	Everywhere	
Cause of death	Roadkill	
I certify that the particulars given by me above are true to the best of my knowledge and belief. Human		
Date of registration Everyday	Signature of registrar	Human

[1]In 2020 data from 90 European roadkill surveys concluded that on Europe's roads 29 million mammals and 194 million birds die annually. Similar calculations suggest that, each year, more than 350 million vertebrate animals are killed by traffic in the USA.

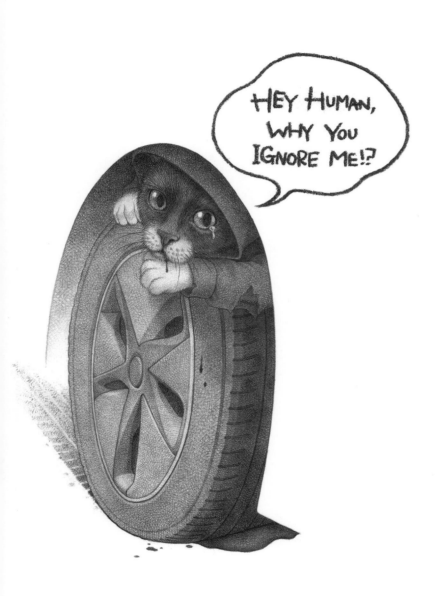

[1]There is an estimated 75 to 199 million tons of plastic waste currently in our oceans, with a further 33 billion pounds of plastic entering the marine environment every single year.

[2]100 million marine animals die each year from plastic waste alone.

[3]In the past 10 years, we've made more plastic than the last century.

[4]The largest trash site on the planet is the Great Pacific Garbage Patch, twice the surface area of Texas, it outnumbers sea life there 6 to 1.

[5]There are 5.25 trillion pieces of plastic waste estimated to be in our oceans. 269,000 tons float, 4 billion microfibers per km^2 dwell below the surface.

[6]Plastics take 500-1000 years to degrade; currently 79% is sent to landfills or the ocean, while only 9% is recycled, and 12% gets incinerated.

2

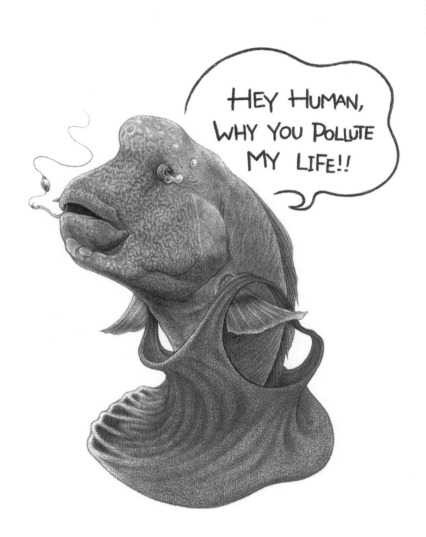

REFERENCE

Page 14: *1/2* - www.eia-international.org. The environmental investigation agency 'TheTiger Skin Trail'. *3* - www.Peta.org.uk. People for the Ethical Treatment of Animals.
https://www.peta.org.uk/blog/6-kinds-of-tiger-abuse

Page 16: *1/2* - https://www.collectivefashionjustice.org/crocodile-skin.

3 - https://investigations.peta.org/vietnam-crocodile-skin-farm

Page 18: *1* - https://www.peta.org/issues/animals-used-for-clothing/wool-industry.

2/3 - https://www.idausa.org/campaign/farmed-animal/wool-cruelty

Page 20: *1/4* - https://www.dosomething.org/us/facts/11-facts-about-animal-testing.

5 - https://www.peta.org/issues/animals-used-for-experimentation/animals-used-experimentation-factsheets/animal-experiments-overview

Page 22: *1/2* - https://investigations.peta.org/badger-brush-industry.

3 - https://www.peta.org/blog/companies-ban-badger-hair

Page 24: *1* - https://en.wikipedia.org/wiki/Velvet_antler.

2/3 - https://secure.petaasia.com/page/138615/action/1?locale=en-US

Page 26: *1/2* - www.four-paws.org.uk. *3* - www.animalsasia.org/intl/end-bear-bile-farming-2017.html

Page 28: *1* - www.spana.org. *2* - https://www.peta.org/blog/are-you-eating-donkey-skin-heres-how-tell. *3* - www.veganpeace.com/animal_cruelty/donkeys.htm.

4 - www.thedonkeysanctuary.org.uk/end-the-donkey-skin-trade

Page 30: *1* - www.africanparks.org/save-pangolins. *2* - https://www.zsl.org/what-we-do/conservation/protecting-species/illegal-wildlife-trade.

3/4 - www.worldanimalprotection.org.uk/blogs/5-interesting-facts-about-pangolins

Page 32: *1* - www.smithsonianmag.com/smart-news/oceanic-sharks-and-rays-have-declined-70-1970-180976890. *2* - www.sharks.org/massacre-for-soup. *3* - www.hsi.org/issues/shark-finning/

Page 34: *1/3* - www.hsi.org/issues/shark-finning

Page 36: *1* - www.peta.org/blog/deep-seacrets-about-whales. *2* - https://uk.whales.org/our-4-goals/stop-whaling

Page 38: *1/2* - https://animalequality.org.uk/blog/2022/04/13/why-is-foie-gras-still-legal-in-europe.

3 - https://www.peta.org/issues/animals-used-for-food/factory-farming/ducks-geese/foie-gras

Page 40: *1* - https://secure.peta.org.uk/page/79457/action/1?locale=en-GB.

2 - https://batworld.org/bats-and-coronavirus-ebola-and-others-the-facts

Page 42: *1/2* - www.peta.org.uk/blog/civet-coffee-a-sip-of-cruelty.

3 - https://www.bbc.co.uk/news/uk-england-london-24034029

Page 44: *1* - https://awionline.org/press-releases/report-100000-dolphins-small-whales-and-porpoises-slaughtered-globally-each-year.

2 - https://www.onegreenplanet.org/animalsandnature/alarming-facts-about-whaling.

Page 46: *1* - https://friendsoftheearth.uk/sustainable-living/fishing-and-environment.

2 - https://www.penguinsinternational.org/tag/threats-to-penguins.

3/4 - https://oceana.org/blog/top-5-threats-penguins-and-what-you-can-do-help

Page 48: *1* - https://www.science.org/content/article/pesticides-can-harm-bees-twice-larvae-and-adults. *2/3* - https://www.xerces.org/pesticides/risks-pesticides-pollinators

Page 50: *1* - https://www.savetherhino.org/rhino-info/poaching-stats. *2* -
https://www.worldwildlife.org/species/rhino. *3* - https://www.savetherhino.org/rhino-info
/poaching-stats

Page 52: *1* - https://www.worldwildlife.org/initiatives/stopping-elephant-ivory-demand.

2/3 - https://wildaid.org/14-things-you-didnt-know-about-todays-ivory-trade

Page 54: *1/3* - https://www.hsi.org/news-resources/bullfighting-long-cruel-death

Page 56: *1/2* - https://www.peta.org/features/horse-racing-lies. *3* - https://www.rspca.org.au/key-issues/horse-racing

Page 58: *1* - https://eu.usatoday.com/story/news/nation-now/2016/08/12/wildlife-officials-seriously-stop-painting-turtle-shells/88617598. *2* - https://globalnews.ca/news/2875460/stop-painting-turtle-shells-youre-hurting-their-health-florida-wildlife-officials.

3 - https://www.thestandard.com.hk/breaking-news/section/3/116504/Outrage-over-sale-of-spray-painted-turtles

Page 60: *1/2* - https://www.animal-ethics.org/how-fireworks-harm-nonhuman-animals.

3 - https://www.hsi.org/news-resources/fireworks-how-to-keep-animals-safe

Page 64: *1/3* - https://www.paws.org/resources/puppy-mills

Page 66: *1/3* - https://www.peta.org/about-peta/why-peta/declawing-cats

Page 68: *1/3* - https://www.dosomething.org/us/facts/11-facts-about-animal-homelessness

Page 70: *1* - https://www.humanesociety.org/resources/animal-cruelty-facts-and-stats.

2 - https://www.dosomething.org/us/facts/11-facts-about-animal-homelessness#fn10

Page 72: *1/2* - https://www.peta.org/about-peta/why-peta/responsible-breeders.

3 - https://www.peta.org/features/purebred-dog-health-issues

Page 74: *1/2* - https://www.onegreenplanet.org/animalsandnature/the-truth-about-the-exotic-bird-trade-will-make-you-rethink-buying-a-parrot-in-the-pet-shop/

Page 76: *1/3* - https://www.peta.org/features/reasons-never-buy-bunny

Page 78: *1* - https://www.vice.com/en/article/dpdnp7/yo1-v14n10.

2 - https://www.orangutan.or.id/update-on-pony

Page 80: *1/3* - https://www.lcanimal.org/index.php/campaigns/elephants/wild-vs-captive

Page 82: *1/3* - https://www.under30experiences.com/blog/this-is-why-you-shouldnt-feed-the-monkeys

Page 84: *1/2* - https://www.humanesociety.org/all-our-fights/banning-trophy-hunting.

3 - https://www.bornfree.org.uk/raise-the-red-flag/captive-lion-breeding-farms

Page 86: *1* - https://www.peta.org.uk/features/egypt-camels

Page 88: *1* - https://www.peta.org/blog/9-jumbo-reasons-to-avoid-elephant-rides.

2/3 - https://www.worldanimalprotection.ca/news/truth-about-elephant-riding

Page 90: *1* - https://www.animalaid.org.uk/panda-prison.

2/3 - https://www.freedomforanimals.org.uk/blog/10-facts-about-zoos

Page 92: *1/2* - https://www.arcticwwf.org/wildlife/polar-bear/polar-bear-threats.

3 - https://brightly.eco/blog/are-polar-bears-endangered

Page 94: *1* - https://www.bbc.com/future/article/20231002-the-photo-of-the-deepwater-horizon-bird-that-shocked-the-world. *2* - https://safety4sea.com/seven-large-oil-spills-reported-in-2022/

Page 96: *1* - https://animalsaustralia.org/our-work/zoos-and-aquariums/marine-parks-aquariums.

2/3 - https://www.nationalgeographic.com/animals/article/orcas-captivity-welfare

Page 98: *1* - https://www.elephant-world.com/murderous-mary.

2/3 - https://www.lcanimal.org/index.php/campaigns/elephants/wild-vs-captive

Page 100: *1* - https://coconuts.co/hongkong/news/how-shellfish-245-freshwater-turtles-rescued-sea-after-being-freed-taoist-ceremony

Page 102: *1/2* - https://www.worldwildlife.org/stories/what-is-a-walrus-haulout-and-what-does-it-mean-for-the-planet. *3* - https://www.wwf.org.uk/learn/fascinating-facts/walrus

Page 104: *1/3* - https://conserveturtles.org/information-sea-turtles-threats-artificial-lighting

Page 106: *1* - https://www.wellbeingintlstudiesrepository.org/cgi/viewcontent.cgi?article=1132&context=newshsus. *2* - https://uk.whales.org/whales-dolphins/species-guide/beluga-whale. *3* - https://www.seaworldofhurt.com/features/beluga-whales-trapped-at-seaworld

Page 108: *1/4* - https://wwf.panda.org/discover/knowledge_hub/endangered_species/great_apes/gorillas/threats

Page 110: *1/6* - https://www.condorferries.co.uk/marine-ocean-pollution-statistics-facts

Page 112: *1/3* - https://www.endangeredspeciesinternational.org/tarsiersection5.html

Page 114: *1/3* - https://www.worldwildlife.org/stories/freshwater-dolphin-species-and-facts

Page 116: *1* - https://www.fairplanet.org/story/as-hong-kong-slaughters-wild-boars-questions-of-biodiversity-loom

Page 118: 1 - https://www.scientificamerican.com/article/ships-hit-smaller-sea-animals-more-often-than-researchers-thought. 2 - https://us.whales.org/our-4-goals/stop-whaling/stop-dolphin-hunts

Page 120: *1/2* - https://www.peta.org/blog/peta-china-car-crash-tests

Page 122: *1* - https://www.scientificamerican.com/article/roadkill-literally-drives-some-species-to-extinction/

Thank you to all of the organisations for publishing the information online which was researched at the time of going to print in February 2024.

HELPING OUR ANIMALS

Please try to support those organisations which fight for animal rights and work towards their protection and welfare in addition to those campaigning to preserve our natural environment. Here is just a small selection:

www.peta.org - People for the Ethical Treatment of Animals (PETA) is the largest animal rights organization in the world. PETA opposes speciesism, a human-supremacist worldview, and focuses its attention on the four areas in which the largest numbers of animals suffer the most intensely for the longest periods of time: in laboratories, in the food industry, in the clothing trade, and in the entertainment business.

www.wwf.org - Building a future in which people live in harmony with nature, knowing that the well-being of people, wildlife and the environment are closely linked. Striving to safeguard the natural world, helping people live more sustainable and take action against climate change.

www.eia-international.org - Environmental Investigation Agency: Investigating and campaigning against environmental crime and abuse. Exposing transnational wildlife crime, safeguarding global marine ecosystems and campaigning to reduce the impact of climate change.

www.collectivefashionjustice.org - A total ethics fashion system is one which prioritizes life and wellbeing for all, before profit and production. Their mission is to illuminate the interlinked injustices in fashion supply chains that harm the planet, people and our fellow animals.

www.idausa.org - In Defence of Animal is an international animal protection organization. Defending animals, humans, and the environment from abuses and exploitation, and to foster peace between all life. They advocate for changes in laws, human behaviour and enlightenment in the need to protect lives, advance rights, improve welfare and steward environmental protection.

www.lcanimal.org - Last Chance for Animals (LCA) has its roots in fighting and exposing the inherent cruelty of vivisection employing non-violent strategies modelled after social movements.

www.worldanimalprotection.org.uk - Building a new world for animals by tackling the root causes of exploitation and abuse. World Animal Protection challenge and transform the global systems that fuel animal abuse.

www.rspca.org.uk - Pushing for changes in the law to improve the welfare of animals on farms, in labs, in the wild, in paddocks or in the home.

www.conserveturtles.org - It is the mission of Sea Turtle Conservancy to ensure the survival of sea turtles within the Caribbean, Atlantic and Pacific through research, education, training, advocacy and protection of the natural habitats upon which they depend.

www.endangeredspeciesinternational.org - Endangered Species International is strongly committed to reversing the trend of human-induced species extinction, saving endangered animals, and preserving wild places.

www.oceancare.org - Committed to healthy living oceans. OceanCare has been raising its voice on behalf of marine life since 1989. The international marine conservation organisation, holds Special Consultative Status with UN ECOSOC and contributes to Agenda 2030 and the achievement of the Sustainable Development Goals.

www.wvs.org.uk - Worldwide Veterinary Service works tirelessly across the globe to ensure that no animal goes uncared for.

www.ifaw.org - The International Fund for Animal Welfare (IFAW) is a global non-profit helping animals and people thrive together. They are experts and everyday people, working across seas, oceans, and in more than 40 countries around the world. Rescuing rehabiliting and releasing animals, working to restore and protect their natural habitats.

www.worldwildlife.org - Have a vision to build a future in which people live in harmony with nature. To deliver this mission, they work to conserve and restore biodiversity, the web that supports all life on Earth; to reduce humanity's environmental footprint; and to ensure the sustainable use of natural resources to support current and future generations.

www.four-paws.org - The global animal welfare organisation for animals under direct human influence, which reveals suffering, rescues animals in need and protects them. Their vision is a world where humans treat their animals with respect, empathy and understanding.

www.worldanimalprotection.org - Creating a vision for a world where animals live free from suffering - together we can move the world for animals.

www.spana.org - Work to improve the welfare of working animals in need in low-income communities across the world. SPANA's global projects are transforming lives and helping to bring about a world where every working animal lives a healthy and valued life.

www.tusk.org - Supporting forward-thinking and successful conservation intervention in Africa. From the plains of the Serengeti to the rainforests of the Congo Basin, working towards a future in which people and wildlife can both thrive across the African continent.

www.sharktrust.org - Working globally to improve the conservation status of sharks, skates and rays. Advocating for policy changes and generating collective action to support their goals.

www.iucn.org - IUCN is the global authority on the status of the natural world and the measures needed to safeguard it.

www.iucnredlist.org - Established in 1964, the International Union for Conservation of Nature's Red List of Threatened Species has evolved to become the world's most comprehensive information source on the global extinction risk status of animal, fungus and plant species.

www.bornfree.org.uk - Born Free believes that only a global, permanent and comprehensively enforced ban on rhino horn trade will bring the crisis facing rhinos to an end.

www.dosomething.org - One of the largest nonprofits exclusively for young people and change, activating millions of young people across the USA to take action to improve their communities.

www.paws.org - PAWS helps cats, dogs and wild animals go home and thrive – whether home is the family room or the forest.

www.animalsasia.org - Are devoted to ending bear bile farming and improving the welfare of animals across Asia. They promote compassion and respect for animals and work to bring about long-term change.

www.thedonkeysanctuary.org.uk - Working to transform the lives of donkeys across the world for over 50 years. Advocating a world where donkeys live free from suffering and their contribution to humanity is fully valued.

www.zsl.org - Have a vision for the future where wildlife thrives, a more balanced, connected and vibrant world where people and wildlife live better together.

www.hsi.org - Humane Society International works around the globe to promote the human-animal bond, rescue and protect dogs and cats, improve farm animal welfare, protect wildlife, promote animal-free testing and research, respond to disasters and confront cruelty to animals in all of its forms.

www.xerces.org - The Xerces Society for Invertebrate Conservation is an international nonprofit organization that protects the natural world through the conservation of invertebrates and their habitats.

www.wildaid.org - WildAid inspires change and empowers the world to protect wildlife and vital habitats from critical threats including illegal wildlife trafficking, climate change, and illegal fishing.

This book is dedicated to my late father

and

my furry children on the rainbow bridge.